REALISM

REALISM

these are my spoken words

TheStorian

iUniverse, Inc.
Bloomington

Realism
these are my spoken words

iUniverse books may be ordered through booksellers or by contacting:

iUniverse
1663 Liberty Drive
Bloomington, IN 47403
www.iuniverse.com
1-800-Authors (1-800-288-4677)

ISBN: 978-1-4620-6228-7 (sc)
ISBN: 978-1-4620-6229-4 (ebk)

Printed in the United States of America

iUniverse rev. date: 02/18/2012

ACKNOWLEDGEMENT

Most importantly, thanks to Jehovah.

Special thanks to Jaime Cubillos and Jean Mapou for the editing.

Additional thanks to Louis Livrance, my family, Landa Petit, The Claridys, and those that stuck around with me through it all. I wouldn't be in this position without all of you.

A FEELING

A shooting star only passes once a blue moon.

When it does pass, it *glows* like a full-moon.

Your mellow voice leaves me [speechless], un-tune.

And your attractiveness, attracts me

more than I thought it would.

What should? What could?

What is this feeling that I'm feeling?

Are the answers revealing?

The enigmatic wants of wanting you so much

leaves me to the thoughts that I need you,

not so miniature, but, so much.

I need you like I need a breath to breathe,

in order to live.

In other words, I need "you" in "my life"

in order to live.

What is this feeling that I'm feeling?

Are the answers revealing?

Feeling more than blissful to spend each moment

with you.

I adore being with you, that is why I pursue to be with you.

Wow, what is this feeling that I'm feeling?

Are the answers revealing?

The feeling of craving for your lips, and affections,

and behind every mirrored-heart, lucidly, I see your reflection.

And even though we're not connected, I can still feel connections.

What is this feeling that I'm feeling?

Are the answers revealing?

This is a question I constantly ask myself.

The only one who can answer it . . . is "you."

My angel, what is this feeling?

Please, be my answer.

ALL I NEED IS ONE CHANCE

All I need is one chance, one lung, one breath
to express my words verbally.

Coming from inside internally.
Externally, all these scars and bruises hurt me internally.
Literally, literature, in history
there's always a story about heaven and hell.
In this world, instead of seeking to get closer to heaven
we're getting closer to hell.
We're getting closer to it and closer we get,
never realizing it.
It's not that we can't
we just DON'T WANT to realize it.
Until disasters and climate changes conquers.
Until gravity breaks loose, and pulls you away
sucking every breath out of you.
And then, one, lung explodes!

All I need is one chance, one lung, one breath

to express my words verbally.

That way I can be free like no prices,

because the prices I paid were priceless.

On the other hand, the possession of life is the nicest.

I'm grateful that I have it.

And I will continue appreciating it even

when I no longer have it.

All I need is one chance, one lung, one breath

to express my words verbally

and say "even through the entire disturbance

I am still here to say I have one chance, one lung, one breath

to express my words verbally."

CUPCAKE HEAVEN

Inside a factory that processes

dough, mixed with sugar,

and then it moistures

to preserve its form as it

hardens in a hot oven

and then finalizes as a cupcake.

Finally, it drops to a mass bowl full

of cupcakes.

Cupcake heaven

DEAR FATHER

Dear father,

I thank you as if I'm addicted to hear the "denadas,"

and the "you're welcomes,"

thank you.

But the welcome I endure the most is when you

welcomed me into your life,

"bienvenue," welcome.

Since day one, from when I was left solo, you only, [uno]

saw my pain and took my "B.S." but I was young, you know.

22 years later, now that I'm older, winters are getting colder,

and summers getting hotter.

Dear father.

Impetuously, life charged at us like a raging bull.

No Martin Scorsese, no food on the table to eat, but we ate like a

table of pool.

I cried when you sold your favorite car just to pay for my school.

But mine's is left and we'll share it like it's the last one left.

If I'm not left, then I'm right or if I'm right then I'm not left,

but if I'm left, then I'm gone! to find another way to make it.

Oh, and those nights staying up until 5 in the morning studying

that's so WE can make it.

And we will, with the Christ's presence and Jehovah's will.

Amen.

I know you're tired of those nightmares, and those un-slept nights.

Frantic thoughts result to scary frights.

Dear father.

In the darkness, I am the knight

and to you I write,

like I'm King Arthur.

Dear father.

I thank you a million to a billion times for being my father.

P.S.

Your son.

FULL-FAITH EQUALS FAITHFUL

I am here!

Because of a symbol, I am here

to experience what was created

for us,

an earthly paradise.

It's *impossible* to agree that

this earth was created simply

for nothing.

We have the sun to brighten our mornings,

the stars and the moon to lighten

our nightfall.

The substance we can't see

is provided for us to breathe.

The clouds above protect us.

The ground below stands us.

But a-foot is no!

Only cars, and keys we know.

Thrash on streets, it shows

the way we give thanks.

Firings from army tanks

show the way we give thanks.

I don't even think we deserve this.

Man, thanks to a symbol

I can be faithful.

Its existence is enough.

His EXISTENCE is *enough*.

Enough for me to live.

And the fact that I'm living

gives much facts that living

is a gift, not an option.

My life gives me full-faith,

and with this full-faith, I can be faithful.

GOD IS AMAZING

God Is Amazing.

Amazing is God is God is amazing, but backwards.

Either way it works.

You can tell by the WAYS of his works,

and in the days of this earth, it was said:

WE were created from the roots of Adam & Eve's birth.

Have a smirk on your face? He'll change it to a smile.

And for every thousand miles, he would allow you to do only one.

Put more faith in him, he'll allow you to do none.

God is amazing, amazing as he is yes he is amazing.

For every fire blazing, he'll seize them off,

and let the steam evaporate to the clouds, the clouds

"He" created.

This heavenly father, he is amazing.

You give me things that even the most gifted human being can't ever give.

Amazing God, amazing king.

If it wasn't for the amazing God, mankind wouldn't be.

But to some 'men' God just can't be . . . true.

Selah

"God Is Amazing."

I DREAM OF THIS

I dream of this.

I dream of a world where evil is

extinct.

And in the valley of death we

find triumph.

A world, where I am able

to communicate with the lion.

Instead of King of the jungle,

it's Kings of the jungle.

Equally to equal.

We are the people.

The light, the makers,

the originators

multiplying by the number

of generations.

I dream of a world where we unite

with our dead ones

in paradise,

without food shortages,

funeral homes, grave yards.

We live forever.

I dream of a world where there's peace

and tranquility.

A world, where people understand that love

is stronger than strong

and by a bond we are fond

to each other.

I dream of a world where there are

kitchen tables filled with good meals,

and the only hope for my black

brothers will *not* be a record deal.

I dream, Yes, I dream of this.

I'M LOST IN THE CLOUDS

I'm lost in the clouds.

Clouds of clouds are around me.

More like gas of clouds surround me.

No sounds around me.

I'm lost in the clouds and no one is here.

So the only motive is fear.

Loneliness, boldi-ness . . . I need an am-bu-lance.

But wait!

What happens to when I'm gone?

Would I be lost in the clouds, just like now?

Would anyone care? Does anyone miss me?

Is anyone listening?

I guess not, no answer.

Time to pull my pants up

and get going before anything adds up.

Cant' wait until the bad is up.

Bad timings,

can sometimes switch good rhymes to bad rhyming.

Truth turns to lies and lies to lying.

Suicidal statement: wish a car just hits me

while I'm driving.

Dead in the scene!

News reporters and cops in the scene.

Wait!

That's me.

Exactly, that is why I'm lost in the clouds.

I found out why I'm here, but where to go?

Where should my soul go?

The best answer I have is . . . I don't know.

Though, I must go, so I can find my way

by all means, modes, and medians.

Through the mean time

I'm lost in the clouds.

I'M YOUNG BUT MY MIND IS OLDER

I'm me like no other; I'm black like no other.

I'm young but my mind is older.

I'm living in a cold world, yet I can be colder,

below 0 degree Celsius.

The world is dirty, filthy, vulgar, and crude

yet my mind can be the healthiest.

Frantic moments, turbulent, chaotic times

yet I can be the scariest; your worst nightmare.

I choose not to. It's not like I gots too

but I gots to take a different look at life.

A different angle. Let me feed you something.

Negative attracts negative, and if you're trying to be positive

then positive is what you should attract, be pragmatic.

But negative will hunt you, and from a sharp distance

negative can cut you. Cut you off entirely into pieces.

I faced many obstacles that led me to give in.

Tried by many, loved by a few,

and the ones that showed me love are

the ones that I want to reel in.

There were times when I was drowning—till I hit rock bottom.

Then, I bounce back up through gravity.

Up on the surface, I heard a voice said "I got him."

A help in hand pull out the death-defying sea. It was Jesus.

I've been hit by brutal punches.

Then as I'm about to retaliate

I sit there and think as my assault rifle clutches.

Is revenge worth it? Cause if I go shoot then, I'm shooting away my

dreams.

Some say or may think I'm too soft, and think that I can't do it.

Think again because I could and I would it's just that I won't do it.

I'm young but my mind is older.

People tend to bring you down to their level lower than the ants on

the floor.

They tend to say words and contradict you, but those contradicts to

me are tiny

just like those ants on the floor.

See me, I fear no one not even that weapon on your waist belt.

Only thing I fear is God himself.

There were times I asked "why was I born?"

I would have been better off unborn.

That was thinking lugubrious

because I've made it through countless of storms.

I'm still here, enduring young and my mind getting older.

Your mind gets older each time you make a right decision.

How "older" is your mind getting?

INDUSTRIAL MUSIC

He's a killer. So he kills.

He's rich; they're poor, so some rob.

See, what the eyes see it grabs

from the hypnotism.

The mind then starts imitating

like a ventriloquist

and you become the dummy

controlled, a slave,

whatever it says goes.

What is it?

It's Industrial Music.

A beat, some voice overs, surely does the trick

like a magician's specialty.

Slavery all over again, only this time

it's the opposite of omnipresence

not present everywhere. We become like Kenshi

from mortal combat.

Blind.

And each time you try to leave it,

like a boomerang

so you come back.

It's so addicting.

What is it?

It's Industrial Music.

Some like it; some don't like it.

I like it.

The music itself . . .

Yes, the beat is live; yes the lyrics are tight,

yes to the cursing and profanities, yes to the subliminal messages

it sends . . .

And yes to the dream and ambition it brings.

Yes, to the motivation it brings and yes to the pleasure it brings.

Yes, to the faith it brings by just switching the wrong to right.

Who would have thought in this verse I'd write?

What is it?

It's Industrial Music.

A reminder reminds that the thought comes first before the action.

So the action is not first like John Adams.

The thought is George Washington.

And after that reminder if you don't understand, shame on you.

Really it's a shame how we can remember 7 tracks in an album

and not know the first five presidents of the U.S.

Or even better, the first five books in the Holy Bible.

(moment of silence).

Before closure . . .

George Washington, John Adams, Thomas Jefferson, James Madison,

James Monroe.

Predominantly, Genesis, Exodus, Leviticus, Numbers, Deuteronomy.

In anatomy,

I would be flown away to explore endless thoughts.

Thoughts that arose from a beat of its interest.

Thanks to Industrial Music I am able to express myself

In a way . . . in a way . . .

Industrial Music.

L-O-V-E

What's love? L-O-V-E

defines to be:

The laughter the jokes, the fat the Joe's

the jays the los, O.

What love got to do with it?

What's love? L-O-V-E

defines to be:

Essential, emotions, time & devotions

the flowers, the hearts, the cupids, the darts,

the sun, the light, the nights, the dark.

What's love? L-O-V-E

defines to be:

Amor, amour,

the words, the don'ts, the do's,

the letters, the I's the U's.

What comes in between?

What's love? L-O-V-E

defines to be:

Passion, desire, sex, romance,

step in the name of love on a slow dance.

The effects and the affections.

The mirrors the reflections,

inner connections connecting connections.

What's love? L-O-V-E

defines to be:

The sweets, the sour, the limes, the ugly, the fines,

the toasts, the wines, the waits, the lines,

the meanings, the rhymes, the money, the dimes,

the honeys, the flu, the swine. Achoo!

What's love? L-O-V-E

defines to be:

A long or short journey, a mission a jaunt.

Mmm, what about the needs, the wants,

the fire, the smoke, the bombs?

BOOM!

An explosion, in which left you in crumbs.

What's love? L-O-V-E

Defines to be:

Love is an emotion of strong affection and personal attachment.

Love is also a virtue representing all of human kindness, compassion,

and affection; and "the unselfish loyal and benevolent concern for the

good of another" (Wikipedia, 2012).

What's your definition of love?

ONLY GOD CAN JUDGE ME NOW

Speechless! Freedom!

The weak ones. Beat them!

Only God can judge me now.

An organ of vision is an orb.

Pain and suffering is just another word for sweat,

but how much more sweat can my body absorb?

To the absorptions of . . . to the absorptions of . . .

Gotta remain in the silence

if not then the silence becomes soundless.

How's this?

Speechless! Freedom!

The weak ones. Beat them!

Only God can judge me now.

In my beliefs, God is the only judge who can judge me.

In one dictionary's beliefs, God is define as an interjection,

an expression of strong feelings

used to express or emphasize feelings,

such as anger, helplessness, and frustration,

and sometimes considered offensive.

And please don't be offensive when I say.

Speechless! Freedom!

The weak ones. Beat them!

Only God can judge me now.

400 years of slavery resulting to braveries.

The brave ones were not judge fairly.

Why judge if you can't judge fairly?

A Judge is also defined as a Jewish warrior leader.

In Jewish history, any of a succession of warrior

leaders who each temporarily held supreme power in Israel

between Joshua's death and Saul's succession.

It's surely sad how the Jews went through several years of judgment.

Speechless! Freedom!

The weak ones. Beat them!

Only God can judge me now.

Too afraid to express myself, so I express it on my own skin.

Went to an interview, and before the manager took a look at my

resume,

he took a look at my skin.

And then, didn't even bother to begin.

Then, he alleged that it's against the company's law.

And I replied, how?

There are many people out there who has tattoos.

even those that serves and 'protects' the law.

So is that the law? Is that the law for you to judge me?

Speechless!

Freedom.

The weak ones. Beat them!

Only God can judge me now.

People yell freedom in this country especially those trapped in cages.

War and discriminations, jail houses and military bases.

The basic is to gamble freedom in tactic phases.

Too many bloody faces next to shell cases.

People get shot here and others are getting bombed in other places.

Wow, this tragic has been going on for ages.

Everyone is going through it, no matter the ages

especially those that are making minimum wages.

A four year old child was murdered by her own mother,

Lord, God's gracious.

These situations are *not* gracious.

I'm tired!

I'm tired of witnessing the innocent being hurt.

I'm tired of witnessing funeral homes digging dirt.

I'm tired of no one seeing the picture, only picture they

see is the pictures on Facebook.

I just wish they could "C" like the letter on a grade book.

Your life is being graded.

As for mines, it is soon to be annihilated.

I held the nine millimeter close to my temple, no time was wasted.

BLAM!

Only God can judge me now.

PARADISE

Wind, breeze, trees, healthy grass, roots, green leaves.

My mind is at ease.

Flying creatures, direful, unharmful, sores over

an environment that human can only survive with a snorkel.

I sit and contemplate this view.

Rightly, fair, ravishing, comely, beauteous and most of all

beautiful.

Astronomical, as I gaze at the sunny sky.

Warm climate.

What a view.

A view that portraits a different image.

A different image of free will.

A view that sets my spirit free, taken away by the current of air.

I wouldn't trade this view for even life itself.

A view that can cure my eyesight to see the blessings and the good

side of life,

Paradise.

Where would you want to be?

PROBLEMS

So much trouble with the Holocaust & Armies.

Only thing they're doing is harming, and there goes the armed men

carrying assault rifles for what reason?

Non-sense.

For this non-sense, millions and millions of dollars are being spent on

armors.

But then again, there are millions and millions of deaths, sufferings,

and hungers.

Steady looking at the clock. How much longer?

If war is the answer, then what's the answer for these disaster's and

inclement,

in between one's adversary, opponents' body dropping on cements,

so ground leveled.

Everything seems to be rising except our spirits.

Outkast, bombs over Baghdad, I know you hear it.

What's the cause for so many, so many, and so many

graves at the graveyards?

So many.

Why does death feels so much better than living?

When we're living to die, as "death" is the beginning.

Too many diggings, not enough thinking.

Sands are sinking.

The "clock" is ticking.

Someone needs to solve these problems,

before it's too late.

SLIPPING, FALLING, AND I CAN'T GET UP

Walking on no grounds, below the entresol,

cause me to be unbalanced,

and twisting confusions leave my mind stupid

And I fall.

Eyesight is blurry from the dust

that comes from tactic explosions.

And after the explosions all you hear

is screaming, yelling, shots,

or in other word: commotions.

And over the oceans.

And over the oceans,

I can't even hear the distinctive spray

of a Doll's porpoise

when it hits the surface.

Or maybe what's over the surface is hell,

causing them to remain at bottom,

scared to hit the surface.

The surface of fire.

That same fire was used to assassinate

Martin Luther King Jr.

That same fire was flaring from the twin towers.

That same fire caused burning forests,

and if that fire is not omitted,

there will be no more endorsements.

On the other hand, that same fire

is what kept you warm through cold times.

Through cold times, that same fire

is what you're going to use to light up

a spiff to get away from hard times.

Then, when the high is gone

you snap back to reality.

And in reality,

more people are in need of radiology.

Wish it was just a mythology

or just a thought,

that was there just to bother me.

The more I think about it,

the more it bothers me.

To the point it conquers me.

Each time you get up

something always ends up going wrong,

causing you to fall

particularly in the months

of September, and October.

Bad moments seem to always

strike at you like a King Cobra.

Then the venomous thoughts.

The venomous thoughts!

The venomous thoughts!

Start poising your brain

driving you insane.

But the truth is,

it's your surroundings

that are going insane . . .

I'm slipping, I'm falling, and I can't get up.

THE MAN WHO LOST HIS GIRLFRIEND

Misplace his car, lose his keys.

Lose his closet, lose his tees.

He would even lose his fees

and wouldn't stress it,

but he'll be damn full if he loses his girlfriend.

One day the damn full morning day came.

The sunshine disappears

and the turbulent thunders in like storm rain.

It all started, the sorrow, the pain

after he answers on the first, second, third ring.

"I need 50,000 dollars to give you your girlfriend back,

in 24 hours meet me by the 17 street train tracks or

if earlier. And um, this is no game."

Click!

The dial tone is heard,

this man is wordless . . . No word.

Uncanny, strange,

this is serious he thought, replaying the words:

"this is no game."

An hour subtracts, 23 hours left.

He paces away, gasping for breath

"respiration" like Mos Def.

But most def, he needs some cash

and fast, 50 thousand.

He quickly calls his local bank.

As the phone rings, he says to himself:

think-think.

"Hello, good afternoon," the teller greeted.

"Hi, I want to know my available balance."

"Sure, is that all you needed?"

"Yes," he answers as he breathes.

He swaps his information and the teller looks it up.

With every step he takes his eyes are looking up.

His stomach is sizzling like onions and peppers cooking up.

"Checking is zero balance, and savings is

twelve hundred sir, anything else?"

"No, that will be it." He hangs up.

Click!

He calls friends to borrow, no luck.

He checks his wallet, no bucks.

He looks at his phone to call the number back.

He changes his mind.

In his mind, he's thinking

"Why did they kidnap the life of mine?"

He reaches home looking at what should he pawn.

Maybe mom's wedding ring?

However, it's too late the day turns to dawn

and dawn turns to night.

His body starts shaking, confused, and foreboding.

He feels like he's trapped in a tunnel with no light.

No answers, no cash.

2 hours left and like a speed of light 22 hours past.

No sleep, no rest, heart feels like it's pumping out his chest.

He stops! And takes a deep breath . . . He dials the number.

He confesses: "please let her go I'll do anything.

I only have 1200, and my mom's wedding ring.

That is all I can bring."

He continues his talk

He then hears LAUGHTER.

Then after,

his girlfriend gets on the phone.

"Baby I was just playing. I just wanted to see how far you would go

for me.

You are so sweet."

The man drops the phone

"Ain't that's something?"

VISUALIZE

Open your eyes and visualize

the vision of when you think

and mesmerize.

Anything is possible because possible

is anything, only you can make it possible.

Hard work is recommended.

I recommend drive and education.

The drive is the push and

education is knowledge.

Knowledge itself is power.

A power that can control the tick

and the tock after each second

you spend on your focus frame: success.

Just visualize your success being only an inch away.

Just visualize down success lane is where you made your way.

You accomplished your goals minus the goal keeper.

Even when you had to face the grim reaper.

Rip through obstacles,

follow the green lights and "obey" the red ones.

Reach for the stars and I'm not telling you to be astronomical.

Just be logical.

Logic is common sense.

And once you get the sense of it

you enter the sense of it

and start sensing changes,

and formations that wonders

beyond the universe.

Not extraterrestrial it's real as celestial.

You just have to visualize.

I want to be a doctor; do you see yourself as one?

I want to be an actor; do you see yourself as one?

I want to be a preacher; do you see yourself as one?

As for me,

I wanted to be a poet; I saw myself as one.

I visualized.

Now, you're reading my spoken words

that are encouraging you to visualize.

Hope you realize that

anything is possible because possible

is anything-only you can make it possible.

Possibility enhances itself by visualization.

It becomes visual. It becomes real.

All you have to do is visualize.

WATERFALLS

Months pass and years flew by like a light year.

Another year has passed with no light.

I'm trapped in a cave where my sorrows dwell.

No motives to move. No motives to live . . .

Tears, tears and more tears.

Tears, tears and more tears.

I'm getting weaker from the dehydration

of releasing these tears. It leaves me dehydrated.

Like a sponge, my skin sucks the same tears

from the puddle that has formed.

From each eye socket a system of a waterfall is created.

Waterfalls that symbolize how I still love you.

Waterfalls that show that my heart can't take any more lies.

Waterfalls that symbolize how I wanted to give you my all.

Waterfalls that show my broken heart.

Someone please, come dry my eyes from these waterfalls.

WHAT HAS IT DONE TO YOU?

Realism! I'm losing it.

Sounds of rockets got me loosing in.

In each more giving day, I'm giving in.

My white flag is within.

Unemployment guides seem to overcrowd

my bedroom, feels to condensed

I'm <u>caved</u> in.

Feeling like a cave man.

In the U.S. M.O.B. is a statement.

And, why do I walk on pavement?

And why, and why do I walk on pavement,

when I own two, title statements?

Endure my stomach that is empty,

like my bank is.

Even Obama tries to give us a boost

but I'm not thirsty, my tank is.

Weak stomach, bitter, things are not sweet

non-diabetic,

simple facts, just snatching a purse

from an elderly woman, that is diabetic.

Hunger. Now that's dialectic.

You can't prevaricate, it's the truth

like Lil Wayne in the booth.

There is proof,

there are reasons.

It's not soothing, when the baby teethes.

The non-wet, dried, bold floor

got you slipp'en and fall'en.

Father, Jesus, Jehovah, Lord, God

are the names, you'll be call'en.

Less money into more bills

is more bills into less money

which equals to more pain.

It got you eagerly, pheenin, for inodane.

Excuse me, I meant to say iodine.

Too many thoughts in my brain

got me losing my mind.

I'm losing time.

At the bar with no bullets no gun

but I'm taking shots to the head

to escape the sanity.

The simple fact of your life

being endangered,

got you feeling like a manatee.

You can't run from it

nor can't you hide.

You have to stay out, to survive.

Reporting live to you.

Now, what has it done, to you?

WHEN IT ALL ENDS

What happens, when it all ends?
Would you still be out hoping for a Benz
or contact lens to bring attention to men
or to see what's forward before you begin?
I guess not, but guess what?
I feel it.

Mother Nature is maximizing its wrath
and minimizing its healings.
Moralities are not being followed
hearts are hollowed.
Somebody pray for me.
I repeat somebody pray for me
So I can survive for what's coming
because what's coming is un-surviving,
daunting, demoralizing, serious.
So, are you ready for it?
Honestly, none of us is and I'm serious.

What happens, when it all ends?

Would you still be out hoping for a Benz

or contact lens to bring attention to men

or to see what's forward before you begin?

I guess not, but guess what?

I feel it.

The humid, the humans, the demons.

Greediness caused so many lives living less.

Temptations become unbearable.

Life becomes incapable.

Then, when the "truth" comes out

the True comes out.

And for most, it's a sad picture.

It's too late to realize that good and bad

is just a bad picture.

Against my flesh and onto my soul.

Lord father PLEASE sanctify my soul,

and protect those that are solid like gold.

In my world cup, your blessing IS my goal.

For only you who can answer this question:

What happens when it all ends?

HOY Y MAÑANA

Tú eres a quien espero
hoy y mañana.

Hoy y mañana.

Tú eres muy hermosa, tan maravillosa.
Cuando te veo, mi corazón se rompe.
Pero ahora mi corazón
se rompe porque no estás aquí.
Se rompe porque no puedo tocarte
ni tampoco besarte.

Hoy y mañana.

Tú eres mi luna llena.
Cuando me siento solo
mi estrella, te miro en el cielo.
Y pienso en tus labios, tan dulces
como la miel.

Tú me vuelves loco,

pero loco de satisfacción.

Hoy y mañana

Siento tu cariño.

¿Te olvidaré?, me miento.

Nunca te olvidaré, siempre te espero.

No importa si es en la lluvia,

aquí estoy, esperanto,

hoy y mañana

hasta que regreses.

SU VOZ

Mi corazón escucha

una voz tan amable, tan inocente

como un ángel del cielo.

Una voz

que es más lenta que el aire.

Y su voz es como el aire

que yo respiro.

Oxígeno para mis pulmones,

latiendo, símbolizando el límite

para oír su voz.

Con su voz olvido los remedios.

Me olvido de los problemas del mundo

porque su voz es como

una droga con bendiciones.

Su voz es mi música favorita.

Aunque la repita, la repetiría

todos los días.

Su voz es mi esperanza

de una fantasía.

Me deja con los ojos cerrados

la boca cerrada y los oídos abiertos.

Su voz es lo que me da la fuerza

para vivir otro día.

Hasta en mis sueños puedo oír su voz,

la voz con que duermo.

Con su voz, ya no hay cantantes

porque en mi oído es su voz lo que me canta.

Mi corazón se pone a bailar.

Disfrutando su voz, una voz que quiero oír para siempre.

DAMOU

Lè mwen santi mwen frèt, se ou ki fè san m cho.

Yon chalè ansanm ak yon dife.

Mwen santi lè ou bò kote m.

Sèl je fèmen mwen rete.

Se nan rèv mwen dòmi.

Yon rèv pou nou de

kote n'ap viv lavi pou letènite.

Yon lanmou ki fè m kwè nou damou.

Mwen damou pou ou,

e mwen pa regrèt.

Mwen t'ap regrèt si mwen pat damou.

Cheri mwen damou!

Mwen damou, mwen damou, mwen damou.

Mwen sitèlman damou m'ap chanje non mwen

tanpri rele-m mesye damou.

Nan tout vokabilè mo ki pi dous se damou.

Cheri ankò mwen repete ak tout kè m

mwen damou, mwen damou, mwen damou.

Pa gen lòt moun se pou ou sèl mwen damou!

SYÈL LA FÈ M KWÈ

Syèl la fè-m kwè

Menmsi se sou manti latè ap viv.

Vivan pa dous . . .

Menm pou ki rezon nou ekziste?

Èske se yon benefis pou etènite?

Syèl la fè-m kwè.

Mwen pa janm swèf

paske li ban m dlo pou m bwè.

Li ban m dlo

pou m benyen,

Li ban m dlo pou m wouze jaden.

Flè ak pyebwa ki ban m bon frechè

pou lè m bezwen pran souf.

Menm dlo sa bay lanmè pou m naje

ak pou pwason abite e ki pral ban m manje.

Se yon lavi wololoy, lavi anba lanmè!

Bal pa tire, pa gen bri, se silans nètale.

Pou lavi pa nou

konsa pou rèv mwen ta ye.

Syèl la fè m kwè

paske mwen wè li.

Se ladan Jezi-Kri soti

epi se ladan li retounen

e, l ap resoti-retounen kanmenm.

Syèl la fè m kwè

li ban m maten

midi ak aswè.

Leswa li moutre m lalin

ak zetwal yo.

Le maten li ban m solèy

pou m'wè lavi a pi byen.

Konsa mwen lonje kò mwen,

leve tèt mwen pou mwen gade solèy la.

O! Syèl ou fèm kwè vre

ke gen yon kreyatè ki fò anpil.

Se li ki kreye lanati.

Se li ki bay lavi.